SOFIE BJÖRKGREN-NÄSE

Hand Lettering and Beyond

A BEGINNER'S WORKBOOK FOR THE CREATIVE ART OF DRAWING LETTERS

Hand Lettering and Beyond
Sofie Björkgren-Näse
ISBN 978-91-88369-80-2
© 2023 Dokument Press
Printed in Poland
First printing

DOKUMENT PRESS

Dokument Press, Årstavägen 26, 120 52 Årsta, Sweden
www.dokument.org | info@dokument.org | @dokumentpress

Welcome TO THE Wonderful world OF Lettering

You might be a beginner just starting out (oh, you have such a fun journey ahead of you) or you might be a seasoned letterer. Whatever your skill level is, I'm so happy that you are holding this book! I want to give you the keys to learn lettering if you're a beginner and tips and tricks to develop your skills if you're experienced.

WHO AM I?

My name is Sofie and I'm in love with lettering! I'm a full-time lettering artist and designer living in the beautiful countryside of Kronoby, Finland.

I'm a self taught artist. I have always loved drawing creative and decorative letterforms, and I'm fascinated by how you draw different lettering styles together. I always drew fancy letters in my school books, and when I started to record music with bands I hand-drew the song titles and lyrics for the cover art. Then, suddenly, I was asked to draw logos, name signs and poster art, and I slowly realized that I could pursue a career in hand lettering. I was thrilled! In 2012, I decided to start my own company, and Fia Lotta Jansson Design was born. Soon I started sharing my knowledge in workshops, because I believe creativity is best when shared.

But enough about me, we are here for the lettering, aren't we?

WHAT IS LETTERING?

Lettering is the art of drawing letters. It's all about hand drawing creative and decorative letterforms. Lettering is not the same as handwriting, which is a person's unique way of writing letters. Nor is lettering the same as calligraphy, which is a form of beautiful writing using a special pen.

Typography is not lettering either. Typography is the art of using letters. You use pre-designed typefaces and fonts as you type on a keyboard to create informative or artistic layouts of words and sentences.

In short, *lettering is more playful than calligraphy, more organic than typography and more designed than your own handwriting.*

Lettering is a craft that anybody can do. The best thing about it is that it's so accessible and so easy to learn. All you need is a pen – any pen or pencil will do – and a piece of paper: printer paper, a cheap notepad, a receipt or an old envelope all work perfectly! And you know the basics of lettering because you know how to write letters and that's where we will start. Start simple with what you know, add details and discover new ways of shaping the letters. This is where the creative side of lettering comes in, so give it

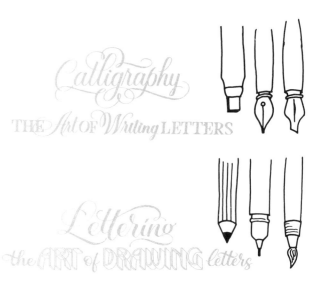

Calligraphy
THE Art OF Writing LETTERS

Lettering
the ART of DRAWING letters

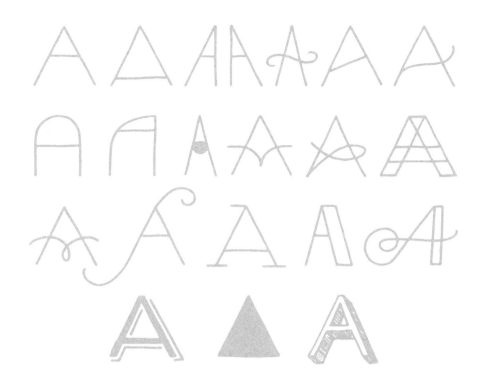

time, doodle a lot and experiment with different letter shapes! Lettering is fun, relaxing and sparks creative joy!

HOW TO USE THE BOOK

In this workbook we will start simple with skeleton letters and then gradually add lines and shapes to our skeletons to create new letter forms and lettering styles. The alphabets in this workbook show the most basic lettering styles. They will give you a good understanding of how the letters are constructed and offer the possibility to embellish, add your own unique touch and create your own fun, stylish, quirky, extraordinary and/or ornamented letterforms.

In addition to these alphabets you will find pages filled with inspiring, creative and decorative letterforms. You can either draw directly on top of them, trace the lines and get to know how the letters are made, or you can copy or be inspired by the different styles and create your own versions on the blank page.

My philosophy as an educator is not to present you with the whole alphabet in every lettering style. I believe in the creativity within you and your ability to use your imagination. So if you see a good-looking A you will be able to take inspiration from that style and recreate it for all the other letters in the alphabet.

Nonetheless, in this workbook we will go through ten whole alphabets, the most basic lettering styles that you can use to develop your own unique letterforms and shapes.

Copying is a great way to learn. You can copy for the sake of practicing, then start to change small details on your copy to create your own letterforms and style.

I encourage you to use this book as a notebook and sketchbook. The blank pages are meant to be filled with your doodles and drawings. If you run out of space, you can easily use ordinary graph paper to continue your practice and exploration of drawing letterforms.

Pencils

I love my pencil, it's my weapon of choice when it comes to lettering. All my ideas start with pencil on paper. I really enjoy doodling and sketching, exploring different letterforms and styles, erasing and redrawing, refining and perfecting before I ink or digitize my lettering. The pencil is such a versatile tool and not as demanding as a fineliner since you can erase and redraw a pencil sketch. Ink is permanent, so you don't get a second chance.

Ordinary graphite pencils need sharpening. It makes drawing details and achieving thin, sharp lines easier. There are soft and hard pencils. A hard pencil, marked with an H, for example 4H, produces a pale line while a soft pencil, marked with a B, for example 6B, produces a darker line.

I normally use a medium pencil such as HB or 2HB.

A mechanical pencil is always sharp. Start with a 0.7, which is softer and easier to erase. When you want to refine your pencil sketch you might want to move on to a 0.5 pencil so you can draw finer lines and details.

A monoline pen creates an evenly thick line, as opposed to a calligraphy pen.

Fineliners / pigment liners

Fineliners, or pigment liners, are ink pens with a thinner or thicker tip. They are also called monoline pens since they create a line of even thickness (unlike calligraphy pens). There are many types of pigment liners. I recommend that you try one in the shop before buying. You will want a pen that doesn't bleed on the paper, and you need a crisp contrast between the ink line and the paper. Choose a water- and fade-proof fineliner so that the ink won't dissolve if you're going to add watercolors to your lettering.

You can either work with one size of pigment liners or use different sizes for enhancing and adding details to your letters.

fineliner 0,05
fineliner 0.2
fineliner 0.3
fineliner 0.4
fineliner 0.5
fineliner 0.7
fineliner 1.0

use one size for EVERYTHING OR MIX SIZES

Eraser

I like to put my money on a high-quality eraser. You don't want it to smudge your pencil drawing. Check the craft store for erasers and not the kid's craft section in the grocery store.

Brush pens

For practicing the lettering styles in this workbook you only need a pencil and a monoline fineliner. But if you want to continue your lettering exploration I can recommend brush lettering, also known as modern calligraphy. You can either use a brush and watercolor, or a pen with a flexible nib for calligraphy-like lettering. Brush lettering is created by thin upstrokes and thick downstrokes.

Gel pens

Gel pens are fun and smooth to draw with, and they come in a variety of colors. The great thing about gel pens is that they are highly opaque. You can draw on colored paper, for example using a white gel pen on black paper.

PAPER

Start drawing on basic, inexpensive paper. If you buy a fancy notebook you might not feel comfortable sketching in it, a fancy notebook can be inhibiting. Blank pages are often inhibiting, so to avoid the blank page scare, start drawing on anything lying around the house, such as envelopes or ordinary printer paper. Soon you may discover that you want to sketch on the move, then a notebook is great to carry in your pocket or bag.

Tracing paper

When you want to refine your sketch, tracing paper is a great help. It's a semi-transparent paper bought in sheets, a pad or on a roll.

When refining or correcting your lettering you place your tracing paper over your sketch and start tracing/copying your drawing onto the tracing paper. You can also draw new details without having to erase the original drawing.

Graph paper

In this workbook we are using graph paper for the simple reason that it's of great help when you're designing letterforms. It gives you reference points and lines that allow you to adjust size and shape. And you will easily find more graph paper after you have used up the pages in the workbook.

Dot grid paper

An alternative to graph paper is dot grid paper. Instead of lines you use dots as a reference. I think this is a great paper and I recommend you to try sketching on it. Two dot grid spreads are found at the back of this workbook.

Watercolor paper

If you want to do a lettering project to give away or hang on your wall you might want to use a more fancy type of paper. Then aquarelle paper, or watercolor, paper is great. It has a good looking grain to it and feels luxurious.

PROCESS

Don't try to achieve perfections when sketching and starting out. For some, drawing letterforms might feel like their natural habitat, but for most it's a bit of a struggle. You might feel insecure about where to start (and since you're holding this workbook you have dealt with that first obstacle, yay!), what words to write, and and it might be frustrating to see that what comes out on paper is not what you imagined. Then it's a good thing to know that lettering takes time! It is a slow sport. Often we need to be bad before we can be good. So allow yourself to be crap in your sketchbook.

Drawing is a process. That's why two of my most important pieces of advice are to *START SIMPLE* and *JUST DRAW*! Don't be afraid of trying and failing. What's the worst thing that can happen if your pencil sketch goes wrong? Well, you might want to erase it, and that's not so bad. But if you dare to try and freely explore your pencil drawing, your lettering can become absolutely spectacularly fantastic, and all without you realising it when you started. Magic can happen when you let your pencil dance on the paper.

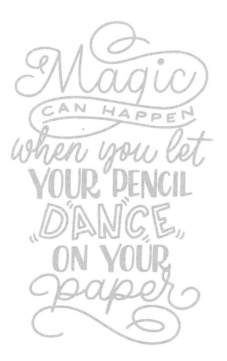

PRACTICE

If you want to get better and become great at something, the trick is to practice every day! Sounds boring, but it's true! So find a moment, preferably every day, a few minutes is enough, and draw a letter or a word (see the the last page of the book for exercises). Doodling is an important part of getting better, so don't expect to always get perfect results when you take the time to draw, just doodle for the sake of doodling. You will see both progress and find new ways to draw your letters. The muscle memory in your hand will get better and you will more easily get the result you want just by doodling.

So practice often, even 5 minutes a day works wonders.

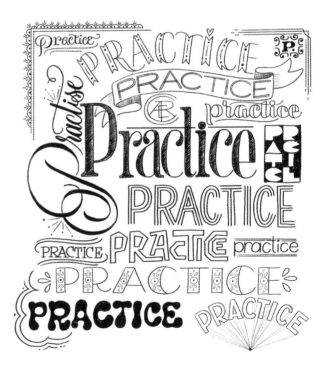

Did you notice the typo? Sometimes you're so focused on making the letters look good that you forget how a word is spelled, or you leave out a letter. It just makes it unique and personal!

ALIGNMENT

I have chosen graph paper for this book since it's a great paper to use as reference when building your letters. You always have straight lines for your base and lines that help you define the height and the width of your letters. (Although I also really like drawing on blank paper, and I don't always care about alignment or the right proportions.)

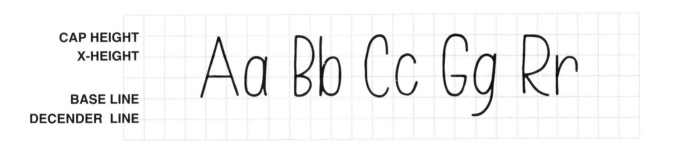

CAP HEIGHT
X-HEIGHT

BASE LINE
DECENDER LINE

SPACING

Letter spacing, or kerning, is sometimes tricky: But it's not the most important thing in the beginning. As you get more experienced you will want to pay more attention to spacing as it balances your work and gives it a good flow. Instead of exactly measuring the space between the letters (metric kerning), which will make the spacing look off, imagine that the spaces are filled with water, and each space holds the same amount of water. That way of kerning is called optical kerning, which makes the spacing more balanced.

STEP-BY-STEP

This is the process I lean on when creating decorative letterforms:

1 Start simple, begin by drawing skeleton letters (more on skeleton letters in a few pages).
2 Draw a frame around your skeleton to create a space you can fill with color or an illustrative motif.
3 Change the shape of the letter by adding or erasing details.
4 Finally, you get to embellish your letters.

This process helps me get a good start and follow through for a great result. I hope it will help you too.

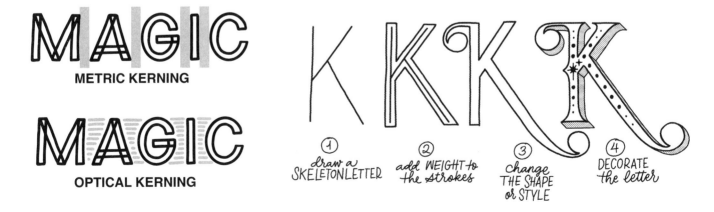

METRIC KERNING

OPTICAL KERNING

① draw a SKELETONLETTER
② add WEIGHT to the strokes
③ change THE SHAPE or STYLE
④ DECORATE the letter

Skeleton Letters

With a great foundation comes great possibilities. Starting out simple will help you "think outside the box" and continue building letters with good-looking details. Skeleton letters are the letters you learned in school and know how to write. Skeleton letters can have different shapes, and we will look at three variations. These variations will be shown in differently shaped boxes. First up is the vertical rectangle.

A a

A a B b C c D d E e F f

G g H h I i J j K k L l

M m N n O o P p Q q

R r S s T t U u V v

W w X x Y y Z z

Next up: how to draw variations of your skeleton letters.

A a → A a + A a

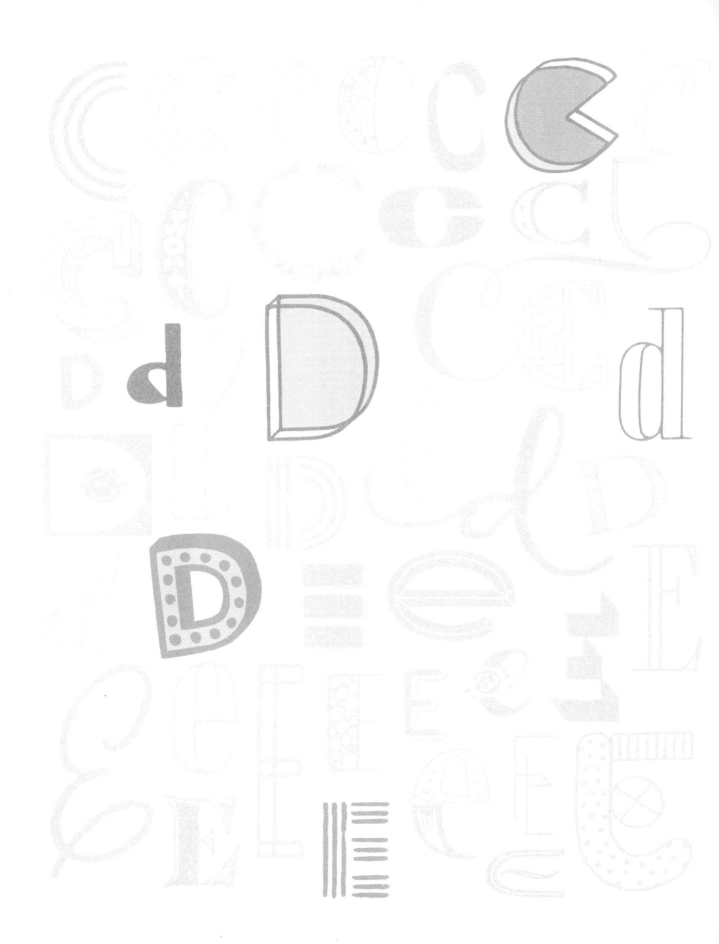

Get inspired!

Skeleton Letters

I love looking at traditional, simple letters in a new way, because sometimes you get bored when writing the same kind of characters you were taught as a kid, and you feel that a change would do them good. The trick is to try to think about these letters as more like shapes than just lines that connect to form a letter. In the previous alphabet we drew the letters inside a vertical rectangle. What happens if you push the rectangle into a horizontal position, what will the letters then look like?

vertical
3 squares high
2 squares wide

vertical
2 squares high
1 square wide

horizontal
2 squares high
3 squares wide

horizontal
1 square high
2 squares wide

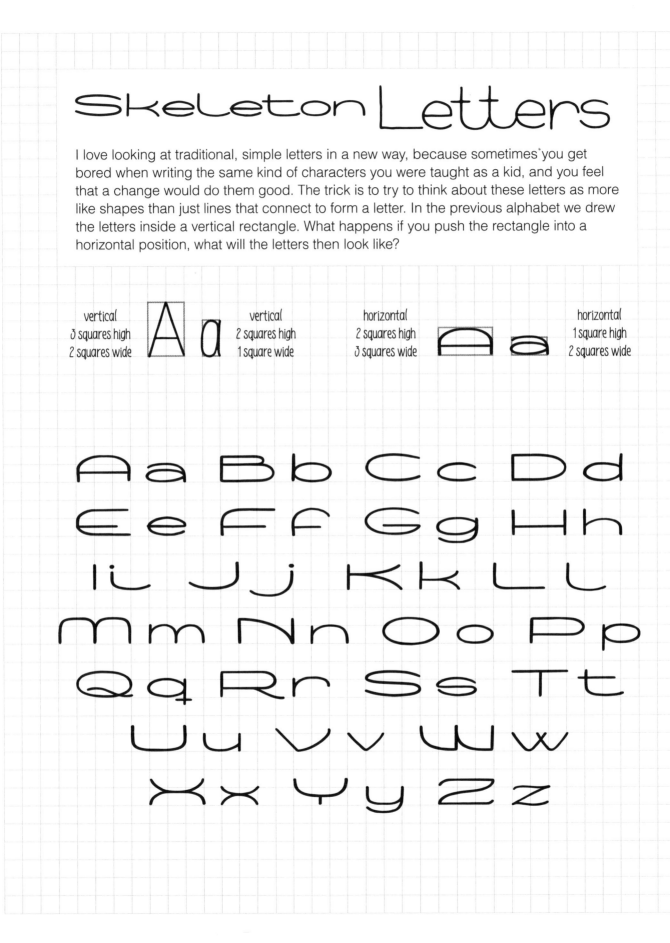

Aa Bb Cc Dd
Ee Ff Gg Hh
Ii Jj Kk Ll
Mm Nn Oo Pp
Qq Rr Ss Tt
Uu Vv Ww
Xx Yy Zz

I love looking at the traditional letters in a new way!
Let's try and make them squared!

from this: 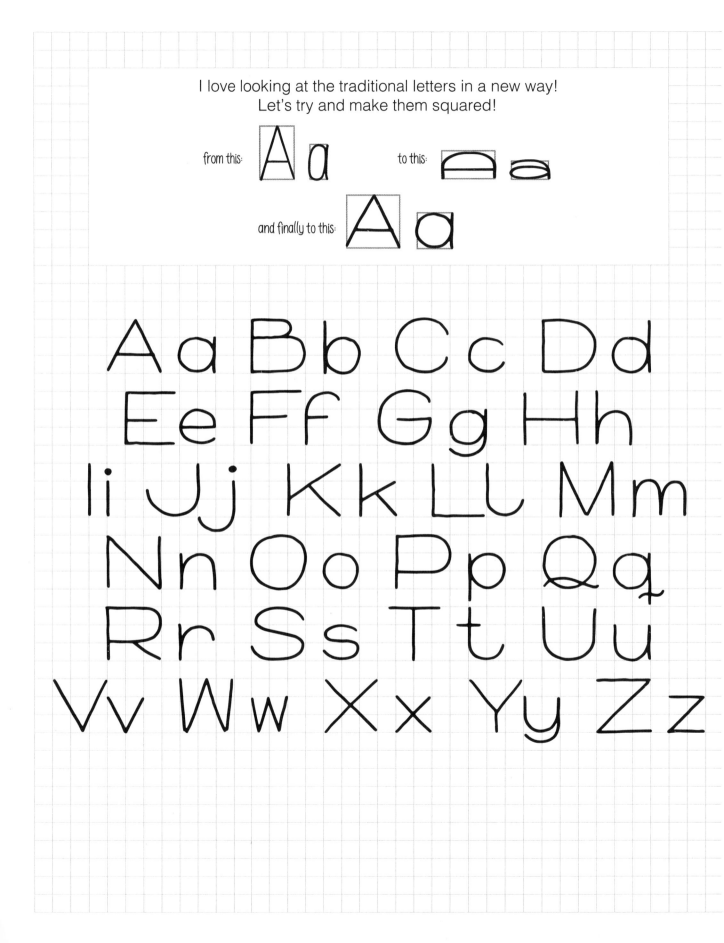 A a to this: ⊟ a

and finally to this: A a

A a B b C c D d
E e F f G g H h
I i J j K k L l M m
N n O o P p Q q
R r S s T t U u
V v W w X x Y y Z z

Next up: let's frame the skeletons and create block letters.

A a → A a

BLOCK LETTERS

Block letters are loud and proud! They are great when you want to communicate important information (like a name on a birthday card or a poster with a manifesto) and they offer a perfect space for embellishment! You can use any style of skeleton letters as the starting point. You can draw either squared or rounded edges depending on what kind of look or feel you're aiming for.

Aa Bb Cc Dd Ee Ff

Gg Hh Ii Jj Kk Ll

Mm Nn Oo Pp Qq

Rr Ss Tt Uu Vv

Ww Xx Yy Zz

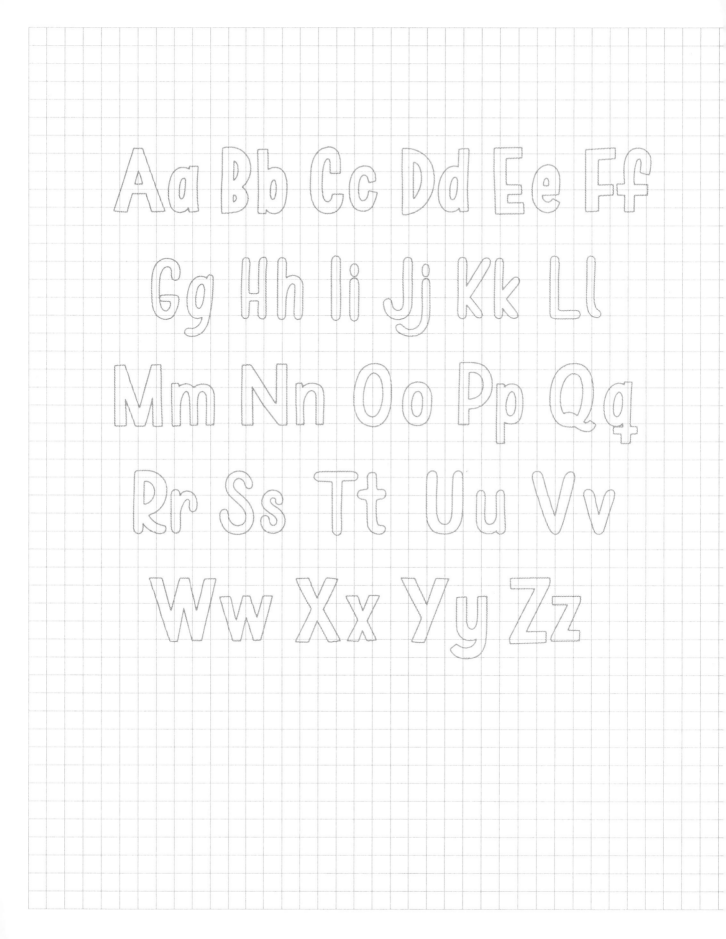

Next up: it is time to decorate your block letters.

Ab → Ab

Just draw!

Going bananas on patterns and decorations is so much fun! You can get inspiration from anywhere: nature, food, wallpaper, textiles and so on. Add basic, decorative shapes and lines. Take inspiration from the embellishments shown in the alphabet below and try to come up with your own decorations!

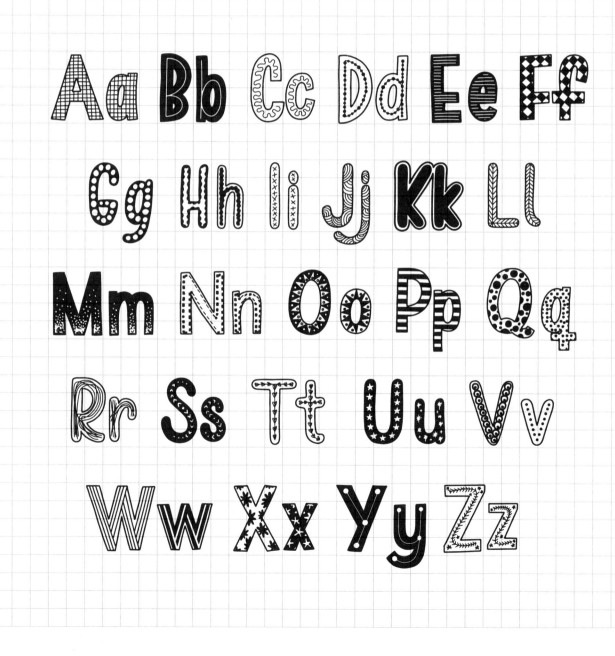

Next up: let's add contrast to your skeleton letters.

A a → A a

WOW :)

Letters with contrast

By adding weight to your downstrokes you can create contrast to your letters.
The downstrokes become thick and the upstrokes and horizontal strokes remain thin.
This gives your letters an old-fashioned and stylish look.

A B C D E F G H I J
K L M N O P Q R
S T U V W X Y Z

a b c d e f g h i j
k l m n o p q r
s t u v w x y z

CONTRaSt

Create low contrast or high contrast letters by varying the thickness of the lines.
Experiment and find out what your favorite contrast is, low or high.

LOW CONTRAST

high contrast

Next up: swashes and swirls!

Aa → Aa

KEEP ON
DRAWING!

Letters with Swirls

Adding swirls to your contrasted letters can brighten up any lettering. It doesn't have to be complicated, even the simplest wave or loop can bring joy to your letterforms. Start by replacing a straight line, for instance the horizontal line in a capital L, with a wave. Or add a loop to the bottom of the right leg of a lower case n. You can swirl a letter in more ways than one, try and find your own way of adding swirls!

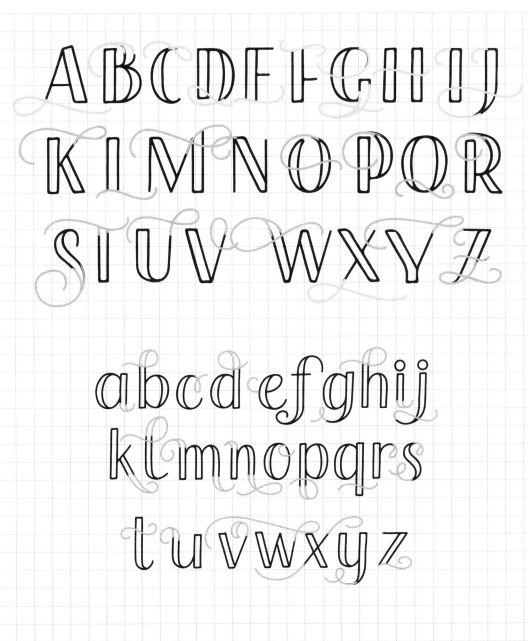

Next up: let's try our hand at *Script Letters* !

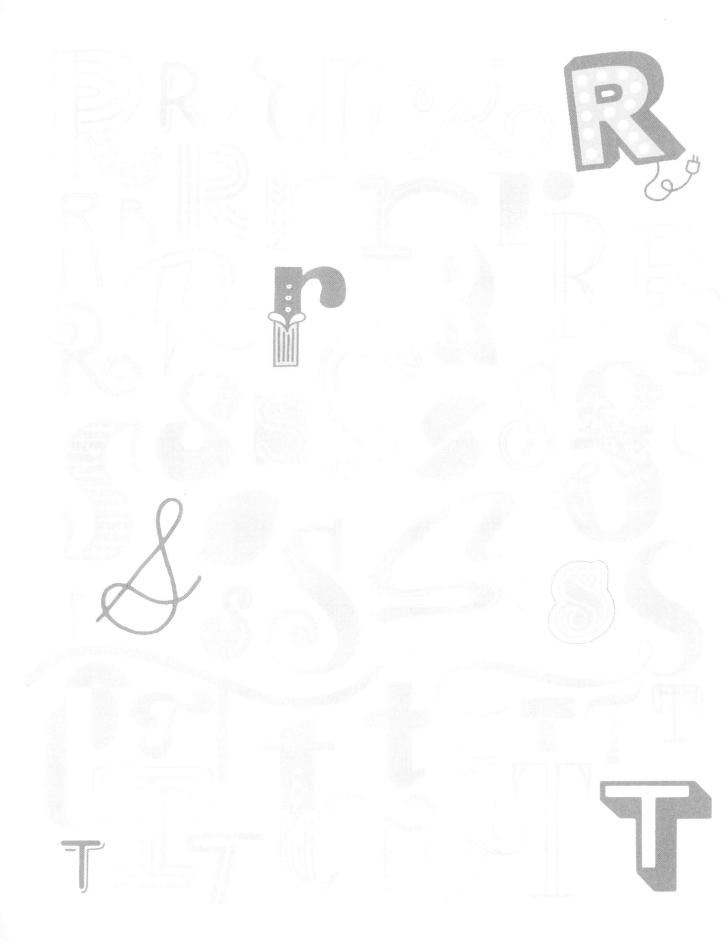

Good job!

Monoline Script Letters

→ Start here

Script is a beautiful way of creating letters. You might have learned script (or cursive) lettering at school and you may like it more or less. It's not used that much today, sadly, because even though it might seem difficult at first, script lettering is very meditative. To put it simply, when writing cursives you connect the letters of a word. The template alphabet below is not a classical script, it's a collection of my favorite script letters. You don't have to follow my lead on these letterforms, you can just be inspired by them. But if you find script lettering difficult you can trace the letters to learn how the letters are built.

Aa Bb Cc Dd Ee Ff

Gg Hh Ii Jj Kk Ll

Mm Nn Oo Pp Qq

Rr Ss Tt Uu Vv

Ww Xx Yy Zz

Next up: we will use convex and concave lines to change the shape of our block letters! A → A A

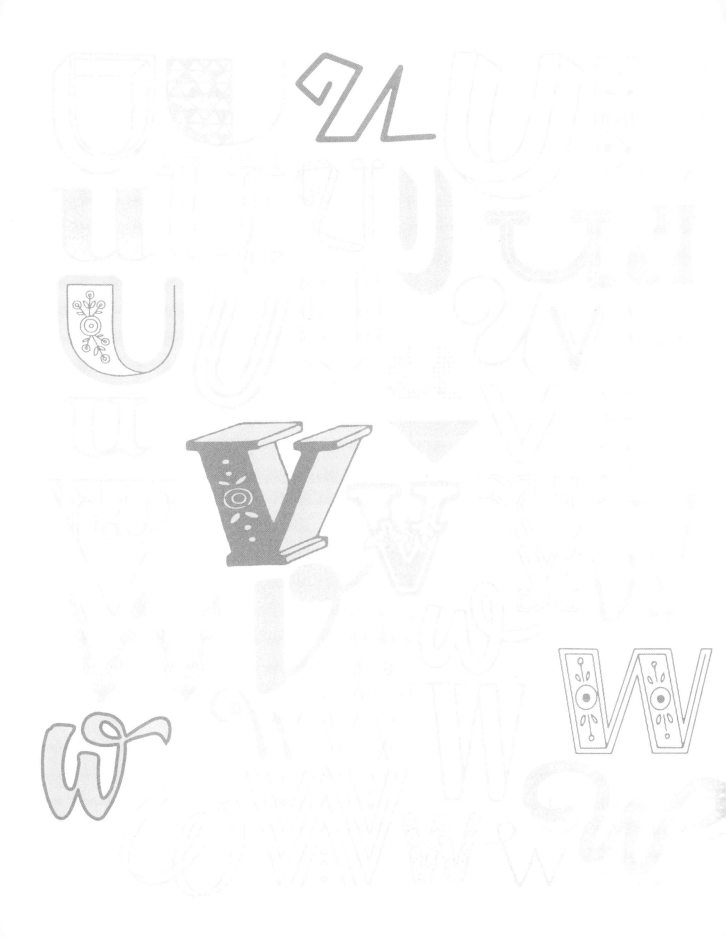

KEEP UP
THE GREAT
WORK!

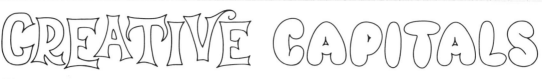

CREATIVE CAPITALS

Block letters are the perfect foundations for creating new and exciting letterforms. Here, I have simply applied convex and concave lines to my skeleton letters.

If you draw a concave line, a line that bulges inwards, you will get Halloween style letters.

If you draw a convex line, a line that bulges outwards, you will get balloon-like letters.

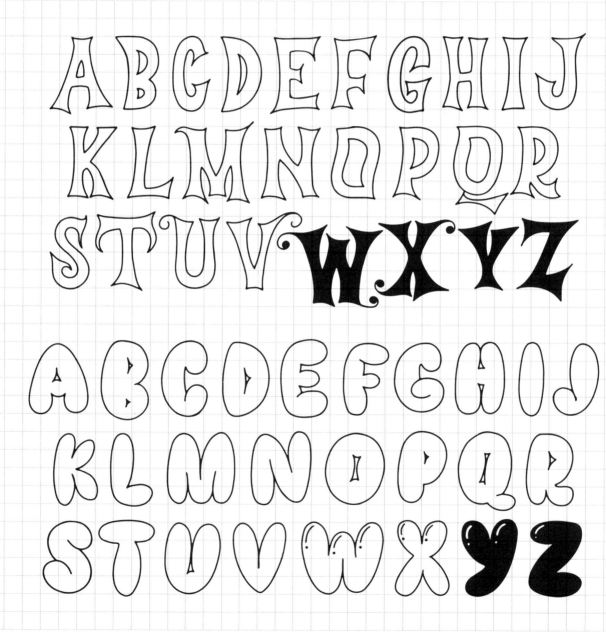

NEVER STOP
CREATING!

Draw some
letters on the
dot grid paper.

Draw some
Letters on the
Dot grid paper.

Lettering Composition

Here is a step-by-step guide to how to design
a piece of lettering with several words.

1 Write down the words you want to work on in
your own handwriting. Mark the most important
words. These are the words you want to enhance
in some way to get the point across.

2 Draw small frames and sketch small thumbnails inside them. These are
quick sketches that allow you to try out different styles, sizes and layouts.

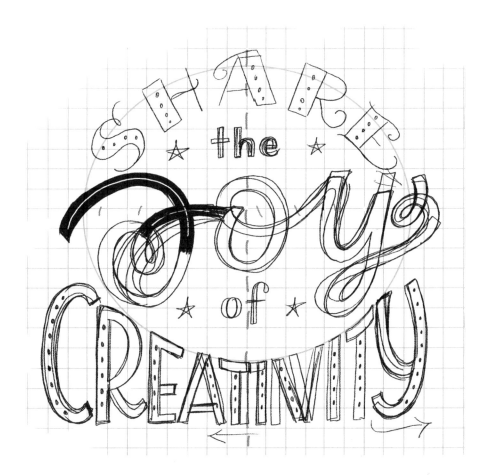

3 Choose the thumbnail you like best and refine it in a larger sketch. Mark the middle of your paper so that you can easily center your words.

4 Make several refined sketches until you feel you're done with your composition. Ink or digitize your sketch for the final result.

sometimes
all you need
is a pencil
and paper.

Get inspired.
TO draw

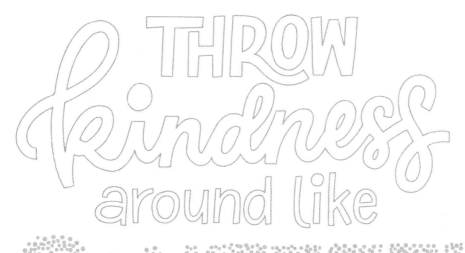

Get inspired.
TO draw

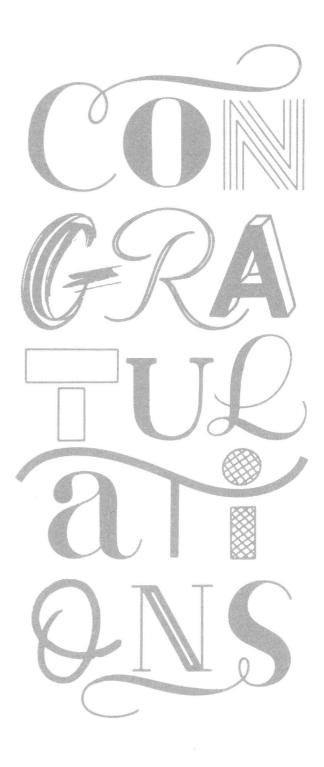

A fun way to draw words is by changing some of the letters into shapes that illustrate the word, or adding decorations that explain the meaning of the word. Here are a few examples. Which word would you like to illustrate?

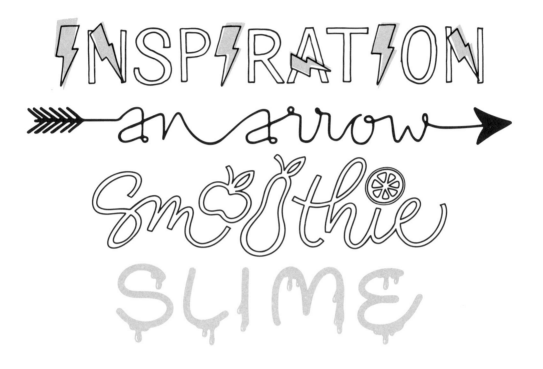

Let go of self-criticism and enjoy the process! Here are two simple exercises that will spark your creative joy and that will let you keep it simple while offering you the possibility to experiment with drawing letters and words in different shapes and styles. Don't strive for a perfect result – be amazed at what you can create just by doodling and sketching!

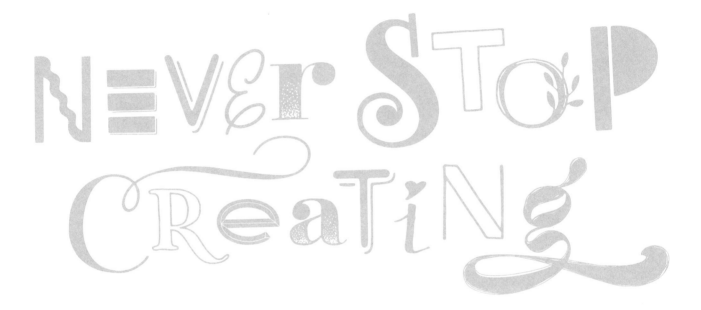

#1word8ways

Take your practice one step further. Instead of one letter, now pick a word! Draw that word in eight different ways. You may have a timer, 20 to 30 minutes is a good timeframe, or you can choose to draw for as long as you like depending on how decorative and illustrative your letterforms are.

I created this exercise as a challenge for me, shared it online and several people have joined in the fun. Look for #1word8ways online and become inspired by what other people have created. Feel free to add your own lettering!

Pick a letter

Choose just one letter from the alphabet. Now draw that letter in as many forms and shapes as you can come up with in ten minutes. Don't use your eraser, just start over if it didn't go the way you wanted. Start simple and just draw and see what happens. If it gets hard and you run out of inspiration, just keep on drawing. Put pen to paper and move your hand. You can draw better than you think!

Just set your timer and start!

If you're curious about my work you're welcome to take a look at my portfolio at www.fialottajansson.com.

And if you scan the QR code you can meet me face to face!